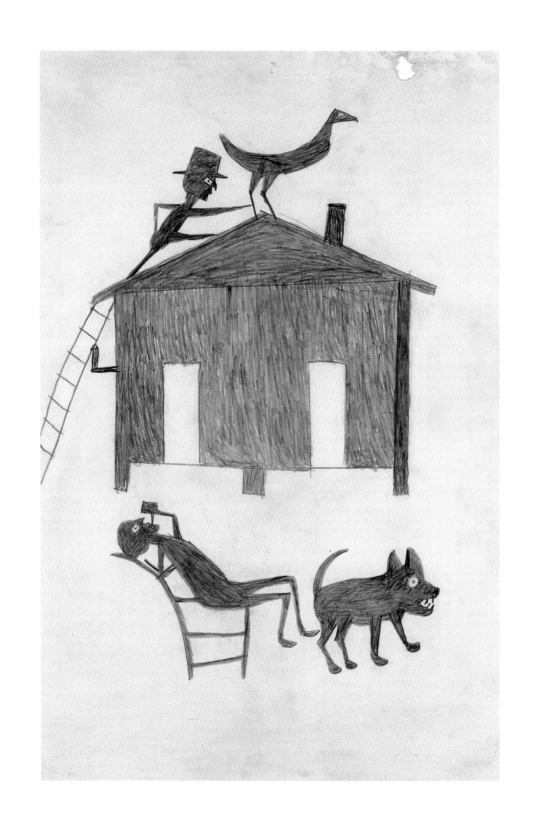

Duane Morris
100th Anniversary

Artwork from the Collection of Duane Morris

Printed in China through colorcraft limited., Hong Kong.
Set in Frutiger 57 Condensed.

Published by:

Fleisher/Ollman Gallery
1616 Walnut Street, Suite 100
Philadelphia, PA 19122

http://www.fleisher-ollmangallery.com

Writers:

Brendan Greaves
William Bones Pym
Jina Valentine

Editing and design by Fleisher/Ollman Gallery

Photography credits:

William Bengston (pp. 11, 47)
Clements/Howcroft (pp. 17, 59)
Rick Gardner (p. 55)
Mark Gulezian (pp. 13, 23, 53, 56)
Marc Goodwin (pp. 39, 43)
Aaron Igler (pp. 25, 33)
Mike Jensen (p. 29)
Joseph Painter (pp. 2, 9, 15, 19, 27, 35, 40, 44, 49, 51, 60)
Tamarind Institute (p. 37)
Jean Vong (p. 7)
John White (pp. 20, 31)

ISBN 0-9621506-7-3
Library of Congress Control Number: 2004093611

Chairman's Message

The year 2004 marks our firm's 100th anniversary. This is a seminal event in the history of Duane Morris. How we practice law and the business of the practice of law have changed dramatically, particularly in the last decade. However, the ethics and values of our 100 year heritage are as relevant today as they were at the birth of the firm. It is this heritage that has contributed more than any other factor to Duane Morris' success.

Although we are a 100 year old firm, rich in tradition and culture, we are very contemporary in the way we practice law. We pride ourselves on our entrepreneurialism and seek to continually challenge the imagination and creativity of our lawyers to deliver the highest quality service possible.

In all of our offices, our artwork is a focal point for a statement about Duane Morris. It is striking, positive in feeling and very different from that found in many law firms. Our art provides a rich environment for our lawyers, staff and visiting clients and friends. We, on our 100th anniversary, take pride in sharing with you some of the artwork from our collection.

– Sheldon Bonovitz
Chairman
Duane Morris

Over the course of the last four decades, Mel Bochner has distinguished himself as an important American conceptual artist, draughtsman, painter, photographer and writer. Known primarily for his seminal conceptual work of the 1960s and '70s, Bochner's long and varied career has recently undergone a critical reevaluation, linking his influence to quarters beyond the conceptual canon. Born in Pittsburgh in 1940, he studied painting at Carnegie Mellon (nearly 20 years after Warhol graduated from the same institution) and then moved to New York. By the late '60s, he had begun making his renowned measurement and number pieces, charting the scale of traditional art surfaces and exhibition spaces by recording their precise dimensions onto prefabricated canvases and gallery walls. Text drawings and paintings featuring multilayered and manipulated words and quotations in lush colors furthered Bochner's philosophical agenda while simultaneously distancing him somewhat from his peers; his work, though academic and cerebral, never forsakes the sensuality of the object itself. Though not exactly painterly, Bochner's two-dimensional work lovingly explores color and texture in ways that his contemporaries often eschewed. His overriding concern is not strictly conceptual, but rather involves a nexus of the conceptual and perceptual, offering an analysis of and commentary on ways of seeing. Bochner's recently reexamined photography from the late '60s extends this investigation through abstracted, formalist close-ups of still-life surface textures. In the 1990s, he adopted a post-Op Art painting style, employing fractured geometry, perspective sleight-of-hand and irregular canvases to plumb the complex relationships between mind, eye, and hand. A recipient of a Guggenheim Fellowship, National Endowment for the Arts Grant and the Skowhegan Medal for Mixed Media, Bochner has placed work with numerous contemporary art institutions and collections.

Untitled 1984

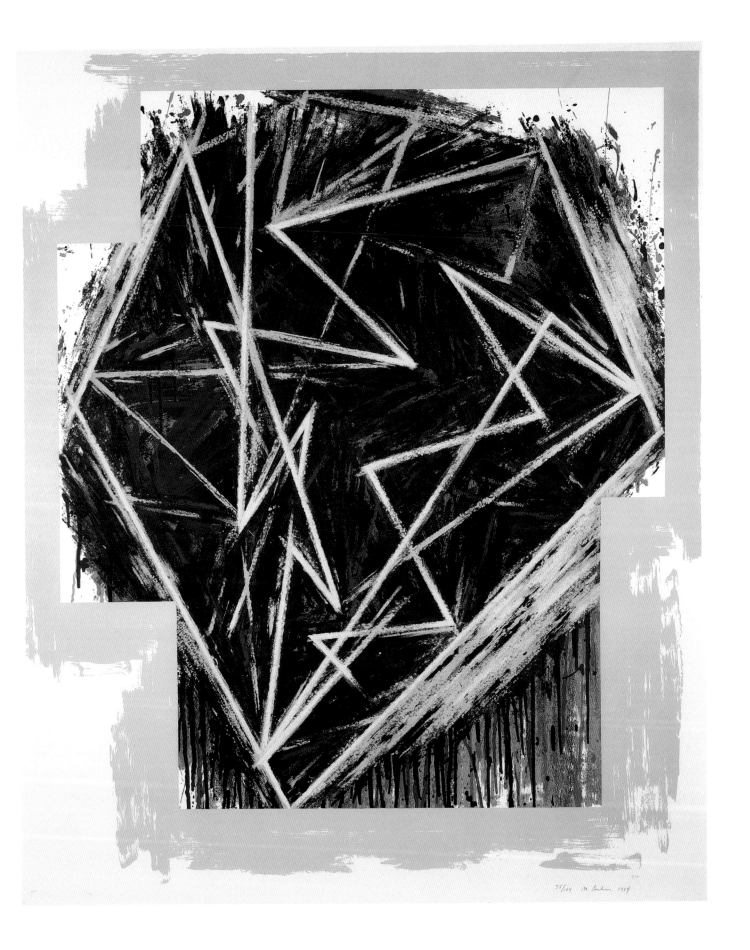

55/144 M. Bochner 1984

Art critic Hilton Kramer dubbed Roy DeForest's paintings "Marx Brothers Fauvism" and his wall relief assemblages "Dude Ranch Dada," both apt descriptions of his playful work, which resists tidy categorization. Considered a member of the California Funk group – a loose affiliation that also implicated disparate artists like Robert Arneson and William T. Wiley, more for their shared attitude of art world rascalism than for any common aesthetic aims – DeForest was born in 1930 in Nebraska, but moved to the West Coast in 1950, where he matriculated at the California School of Fine Arts, San Francisco. Like the contemporaneous East Coast Pop Artists, the California Funk Artists radically altered the playing field, tearing down walls between "high" and "low" culture by appropriating and incorporating both with a slyly ambiguous mixture of reverence and mockery. The Californians, however, tended more toward the light, loose and loony, more generously humorous in their approach, but still retaining some gestural traces left over from the dour Abstract Expressionism against which they railed. DeForest favors certain recurring motifs in his work, particularly tongue-lolling dogs, horses, and cowboys with extravagant hats, all brazenly rendered in oversaturated color throughout dense, patterned compositions. The influence of cartoon imagery and major modernists like Joan Miro and Franz Marc are evident in this energetic drawing from Duane Morris' collection. The handcrafted and painted frame is characteristic, though somewhat tame – DeForest often sets his two-dimensional work in baroque, sculpted frames that weight the work as much as the picture plane itself. DeForest was the subject of a 1974 retrospective at the San Francisco Museum of Modern Art and the Whitney Museum of Art, New York, and since 1982, when he quit teaching at University of California, Davis, he has dedicated himself exclusively to his art, with an increased interest in sculpture.

Untitled (The Redheaded Series) **1984**

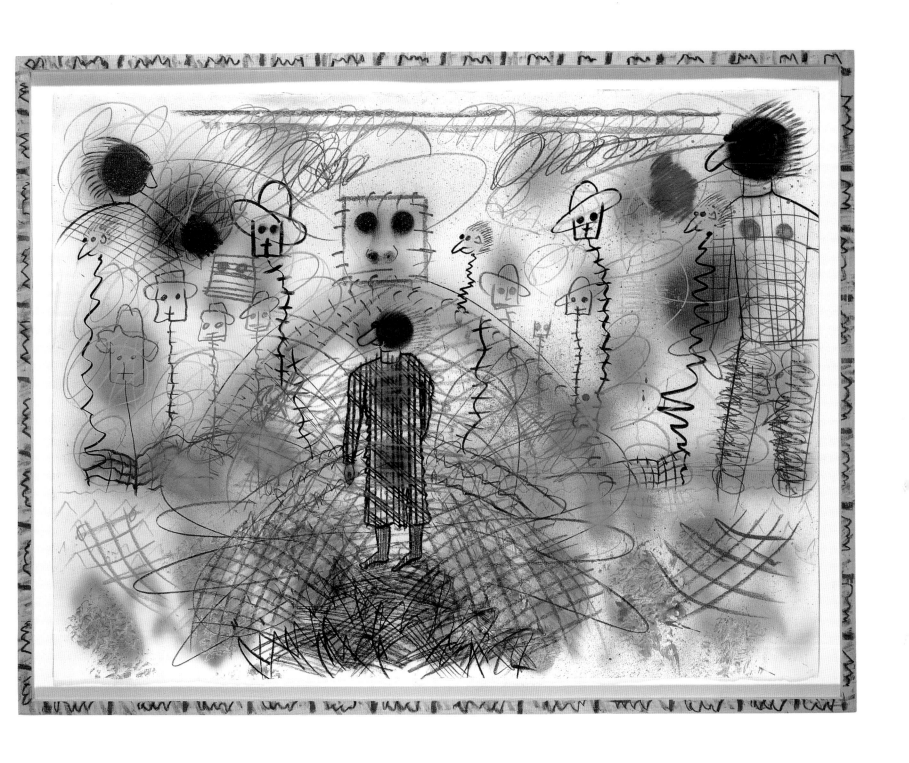

Hawaiian-born Ray Yoshida has taught at the Art Institute of Chicago since 1959, inspiring such now-famous students as artists Jim Nutt, Ed Paschke and Christina Ramberg, and MoMA director Robert Storr. Yoshida is an obsessive collector of shapes, as evidenced by his massive body of intricate collages entirely composed of catalogued scraps from comic books, and it is this compulsive, lifelong investigation of form that makes him the quintessential Imagist artist. Imagism was an irreverent, pyschological, and often slightly perverse reaction to Pop Art's themes, stretching '60s notions of modernity until they were distorted into the realm of the grotesque. Yoshida's "Stretch" seems to depict a highway where powerful cars appear to simultaneously race together and snarl up. Some forms appear to be ominous and murky clouds, others remembered limbs from the trees that once existed there. All the while, this potentially charged composition can be enjoyed simply for its elegant, carefully considered formal qualities. Yoshida was the 2000 recipient of the College Art Association's Award for a Distinguished Body of Work, Exhibition, Presentation or Performance, and his work is held in the collections of The Museum of Contemporary Art, Chicago, the Elvehjem Museum of Art at the University of Wisconsin–Madison, the BankAmerica Corporation Art Collection, the Hallmark Fine Art Collection, The Illinois State Museum and private collections worldwide.

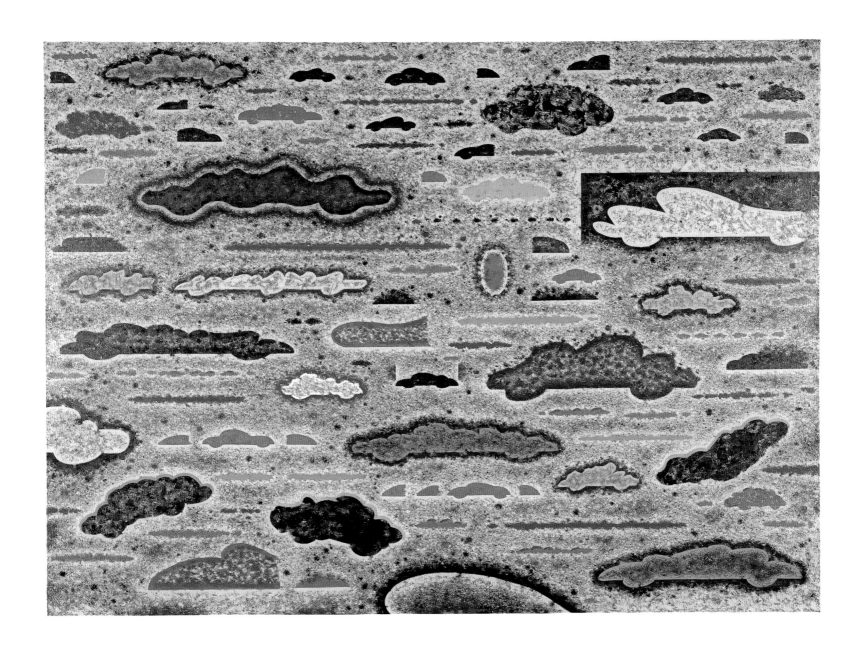

An heir to diverse strands of Modernist discipline, Mark di Suvero's work represents a synthesis of the industrial materials of Minimalism with the architectural rigor of Cubo-Constructivism and the gestural lines of Abstract Expressionism. Born in Shanghai in 1933 to Italian diplomats, at the outbreak of World War II di Suvero and his family moved to California, where he attended the University of California, Berkley, graduating in 1956. Eager to launch his career, he settled for a period in New York City, where a work-related elevator accident left his legs paralyzed for two years but his ambition undaunted. Influenced by Giacometti's 1930s narrative Surrealist sculptures, Calder's kineticism, and David Smith's monumental steel geometry, di Suvero forged a composite aesthetic that established him as one of the most important post-War American sculptors. Manipulating salvaged I-beams with industrial welders, cherry pickers, and cranes, he imparts to his enormous, often site-specific work a precarious equilibrium, cheating gravity with apparently effortless lyricism. Engineering feats in themselves, his skeletal pieces dominate and define the spaces they occupy, defying their very solidity and mass by revealing their elegant, organic harmony through playful kinetic elements and a lack of illusionist artifice. Currently represented by Gagosian Galleries in New York, di Suvero was the subject of a major 1975 retrospective at the Whitney Museum. He is the only living artist to exhibit at the Louvre's Jardin des Tuileries, and his work can be viewed in institutions worldwide.

Untitled 2002

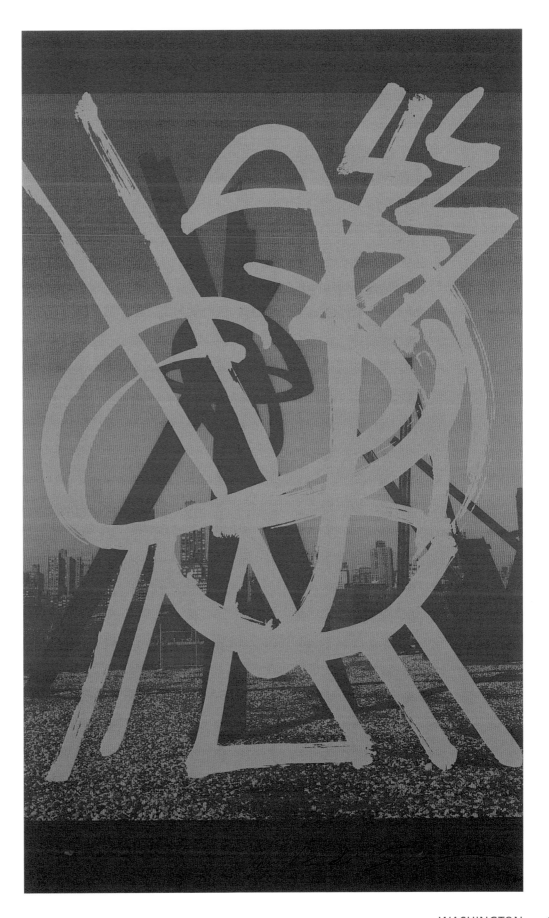

Born in Mexico City in 1961, César Núñez first exhibited his drawings in 1977, at age 16. His work is a combined product of Mexican and European art educations, reflecting his studies at the Escuela Nacional de Artes Plásticas de San Carlos, Mexico City, and at the École Nationale Supérieure des Beaux-Arts in Paris. While still in Mexico, Núñez became affiliated with Grupo Suma, an artists' collective active from 1976 through 1982, which drew inspiration from archetypal and traditional Mexican images, engaging in public projects that addressed contemporary Mexican society on a street level. In 1981 Núñez traveled to Paris on a scholarship from the French government, apprenticing in the studios of Pierre Alechinsky and Jan Voss. Following his graduation in 1989, the artist moved to Berlin, finally returning to Mexico in 1992. This international pedigree has instilled in Núñez's work a fascinating juncture between indigenous Tepoztec ritual, the ephemeral festivity of Mexican Day of the Dead ceremonies, and the processes of European postmodernism, all typified in "Anasazi." Núñez builds up his expressionistic surfaces with paint, charcoal, ink and other found matter, evoking cave painting and contemporary abstraction alike with his vivid fields of fiery, enmeshed animals, demons, skeletons, and human figures.

Anasazi 1996

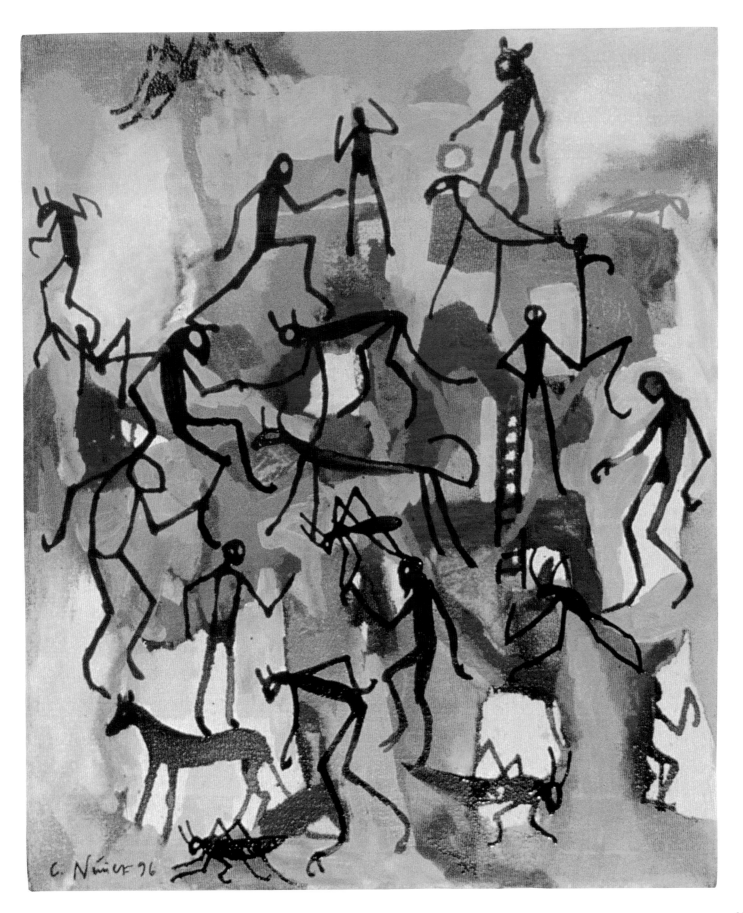

This Peruvian textile fragment dates to 1300 A.D., during the transitional period known as the Period of Regional States (circa 1100-1438), an era characterized by sociopolitical instability resulting from gradually expanding city-states and tribal units. This epoch likewise represents the beginning of recorded history in Peru, as well as the proliferation of city-building. After the collapse of the dominant Tiahuanaco-Huari culture, which ruled by divine prerogative, and before the rise and consolidation of the massive Incan empire, a widespread secularization of Peruvian culture instigated a striking regression in ceramic arts coupled with certain advances in agriculture and technology. Fortunately, textiles from this period maintained their high artistic value and even advanced through the development of new methods of weaving and dyeing by pre-Incan weavers. However, with the waning of religious fervor accompanying the Tiahuanaco retreat back into the mountains, the imagery became increasingly abstract and ornamental, with a noticeable absence of divine figuration, ceremonial purpose, and spiritual content. The pattern and repetition in this work prefigures approaches and themes found in modern art six centuries later. Duane Morris owns three textile fragments from this period, each exhibiting variations on the remarkably subtle and sophisticated decorative aims of a culture on the brink of upheaval and reinvention at the hands on the Incas.

Manta c. 1300 A.D.

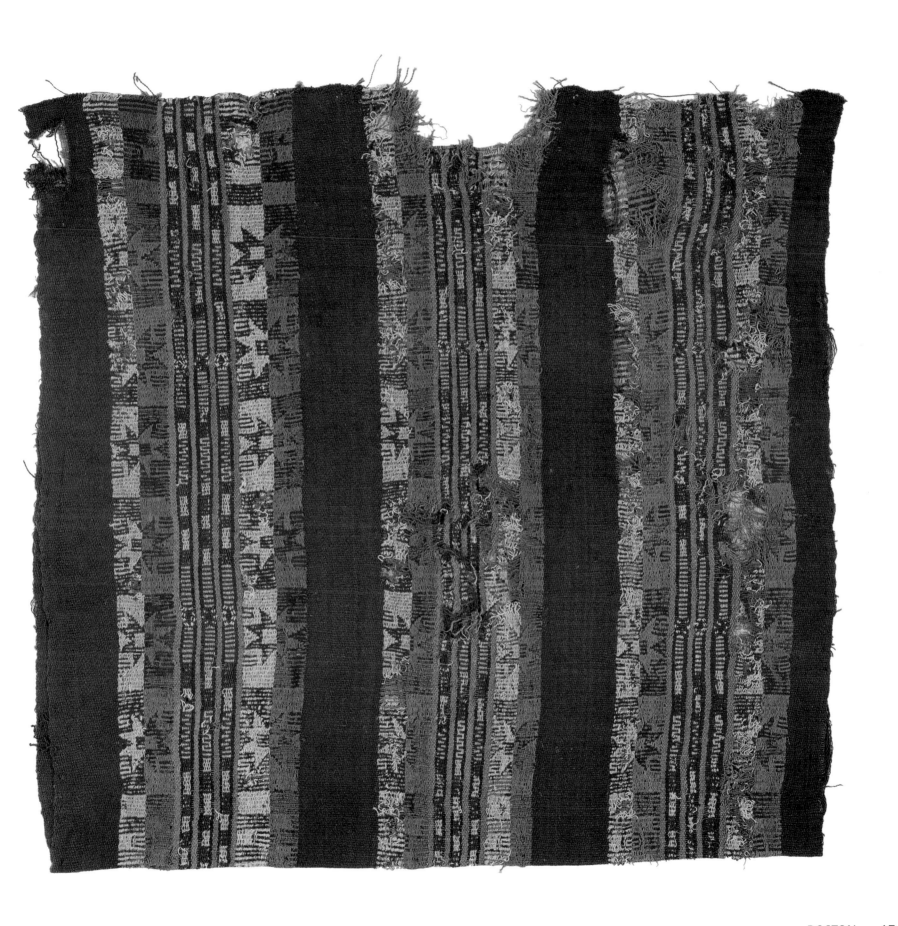

As proudly inscribed on most of his paintings, William Hawkins was born in Kentucky on July 27, 1895, though he spent much of his adult life in and around Columbus, Ohio, where he moved in 1916 to avoid a shotgun wedding. One of the most famous and highly regarded African-American self-taught artists of the twentieth century, before his retirement Hawkins worked tirelessly at numerous jobs – often simultaneously – ranging from breaking horses and running numbers to industrial steel casting and truck driving. He served in the Army in World War One, working burial details in France. Hawkins began painting in the 1930s, though he only dedicated himself exclusively to art around 1979, when he was discovered by neighboring artist Lee Garrett, leading to national attention and what collectors generally describe as his mature period. Tending to paint with a single brush and semigloss enamels on large plywood and Masonite scraps, he often worked from his own black-and-white photographs of buildings and animals, boldly articulating his unique, expressionistic interpretations of architectural form, religious subjects, and nature studies in bright color and broad, patterned brushstrokes. By the time of his death in 1990, Hawkins had amassed a body of approximately 500 paintings and pencil drawings, not counting his lost early pieces, gradually turning toward human figuration in his final years. "The Yaekle Building" is a fine representation of the artist's preoccupation with architecture, offering a highly personal vision of a favorite building rendered in a restrained palette, with collaged found objects to designate depth and dimension in lieu of perspective or detail. William Hawkins is one of America's most widely exhibited and collectable folk painters, and his work can be found at the American Folk Art Museum, New York; the High Museum, Atlanta; the National Gallery, Washington, D.C.; and the Columbus and Akron Museums in Ohio.

The Yaekle Building **1987**

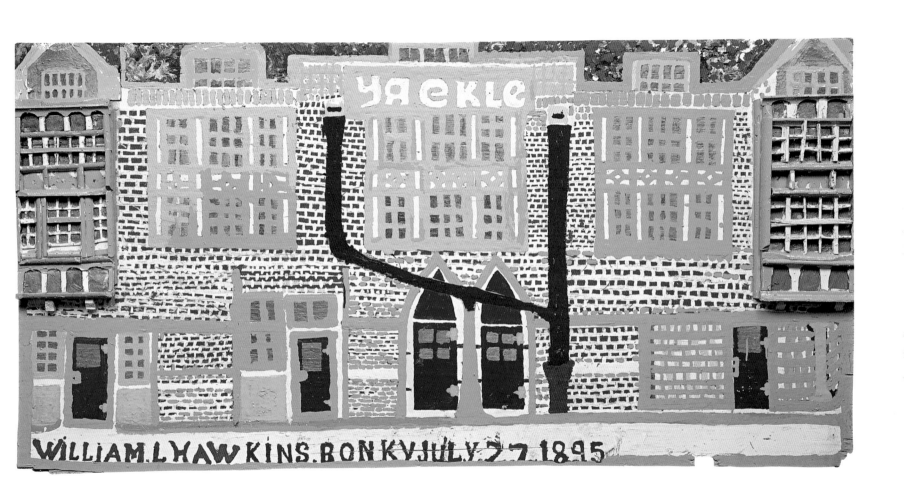

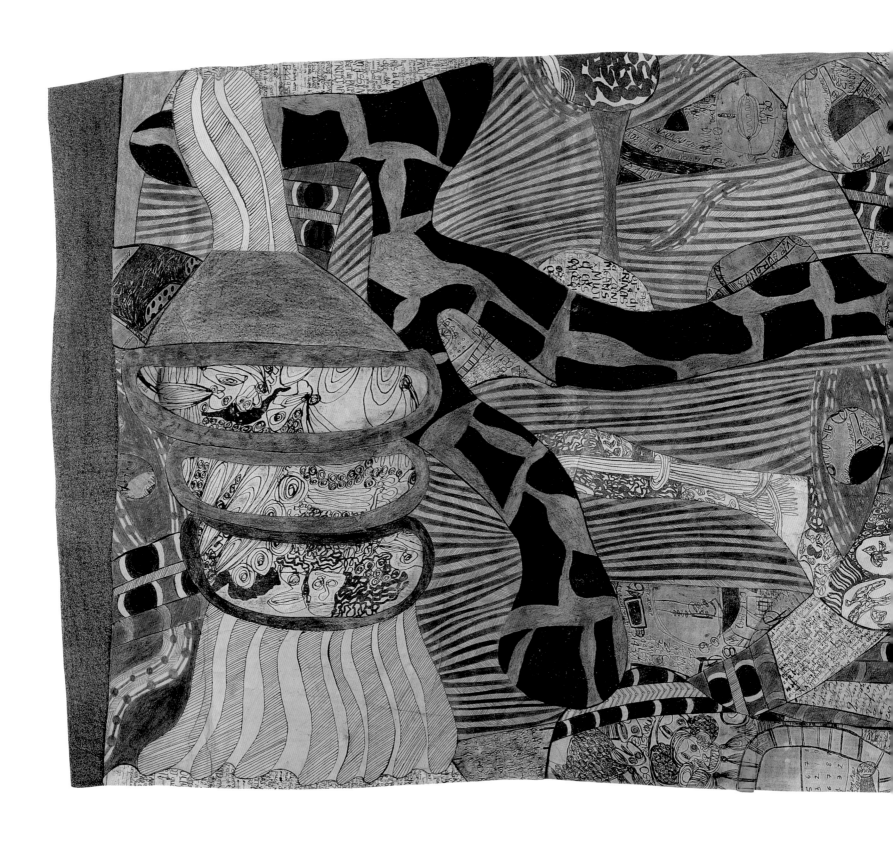

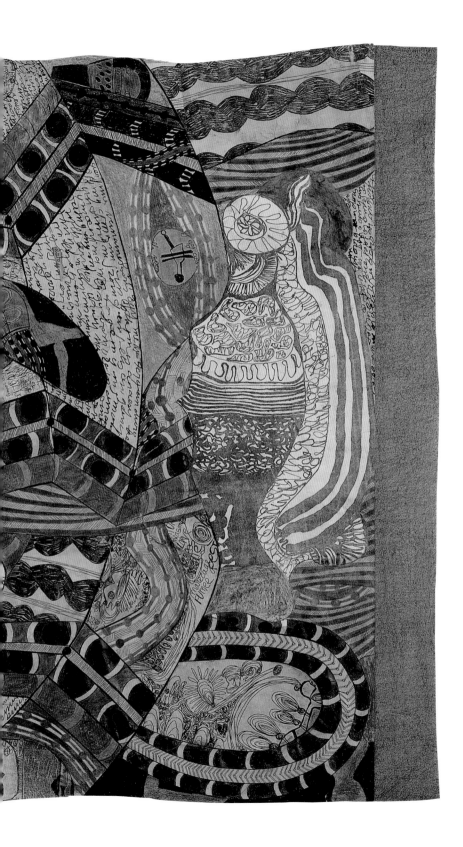

Born in 1951, French calligrapher, phenomenist, linguist, Geneviève Seillé is fascinated by "the beauty of lines called letters," the anatomy of text, and the translation of observed phenomena into expressionistic characters. Seillé's process closely follows that of scientist and writer Pliny the Elder (23-79 A.D.), who passionately observed various phenomena while taking highly detailed notes. This sort of personalized observational research technique, when combined with Seillé's observations of music and medieval books on anatomy and armor, result in densely woven, (almost) illegible, calligraphy in French, English, and Latin. By incorporating random imagery, figure drawing/portrait as some attempt to understand their physiognomy and anatomy simultaneously, she constructs her own "cosmology." Seillé employs a *preadult logic* where nothing is predetermined, and the final result is immediate and unpredictable. The paper may start small and grow as the observation grows, and pages may be glued on the edges in irregular patterns until she makes her conclusions. Her work can be found in the Sackner Archive of Concrete Poetry in Miami and the National Art Library in Britain.

Biomorphic Architecture 1994

Philip Taaffe was born in Elizabeth, New Jersey in 1955. He attended the prestigious Cooper Union in Manhattan, studying painting and printmaking. At 27 years old Taaffe showed solo at Roger Litz Gallery, and from there he danced through the most hip and significant galleries of 1980s New York, as well as Paris, London, Hamburg, Cologne and Beverly Hills. Taaffe stands out in the glittering ranks of Eighties art stars by virtue of his academic discipline and commitment to mastery; his passion for the decorative arts, for repetititve pattern, spirituality of simple form, and textile printing techniques led him to extensive travels in Egypt, Morocco, Tunisia and India. Represented since 1991 by Gagosian Gallery, Taaffe remains devoted to his reflective vision of modern reverence through color and shape. He has been given numerous important museum exhibitions, including the Hayward Gallery, the Carnegie International, two Whitney Biennials and most recently the IVAM Centre del Carme in Valencia, Spain. His work can be found in the permanent collections of the Museum of Modern Art, the Philadelphia Museum of Art and scores of important private collections worldwide.

Untitled 1999

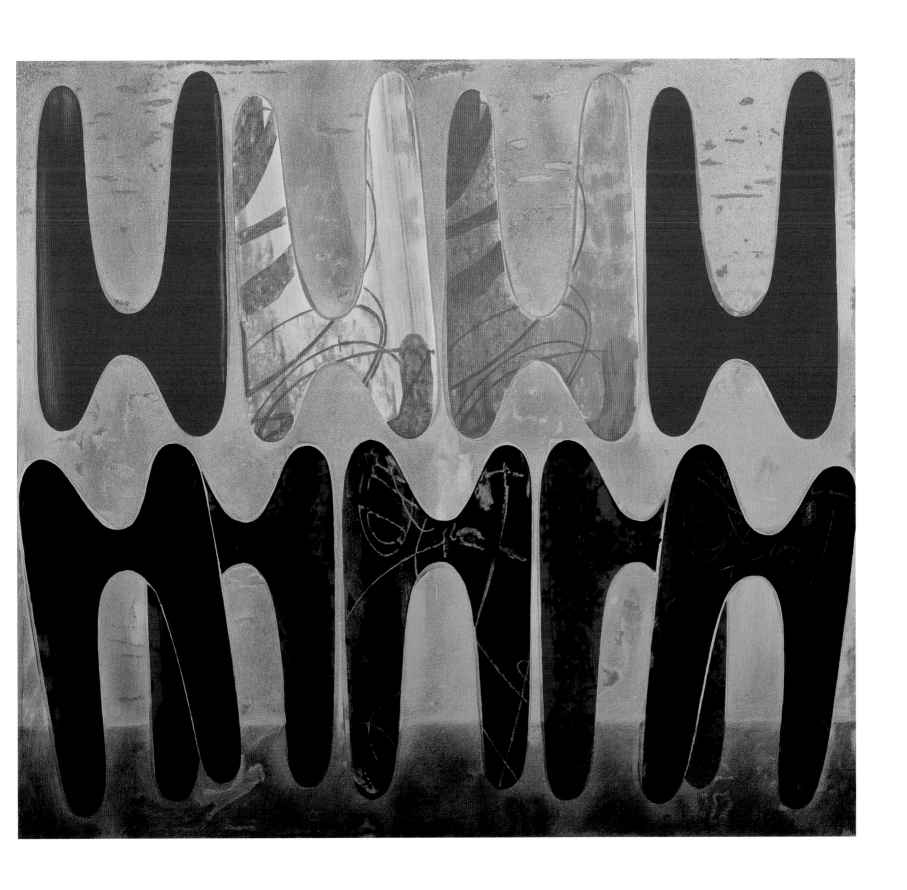

Born Robert Clark in rural Indiana in 1928, the painter had studied extensively in Chicago, New York, Edinburgh and London by the time he settled in New York in the early '50s. Thanks to the young Pop Art movement, Robert Indiana could draw inspiration from his beloved midwestern boyhood and its burgeoning highway advertising of glowing roadside icons and promises. Indiana's arresting images incorporate the functional typography and snappy colorways of traffic signs, amusement machines and commercial stencils, in addition to pop tropes as familiar as Marilyn Monroe and Old Glory. In 1966 he made "Love," the unforgettable and epoch-making design that defined hippies and squares alike with its both simplistic and completely whole message of the 1960s. The square formation of the four letters, the leaning letter O and its red, green and blue fills has been immortalized as a postage stamp and is the symbolic fulcrum of the famous Love Park outside City Hall in Philadelphia. Indiana appeared in the legendary Kassel Quinquennial Documenta 4 in 1968, and his impact and influence has yet to diminish. When asked if Pop is "easy art," Indiana takes exception. "Pop is instant art," he says. It still is, too, and Duane Morris is lucky to have a piece.

The Figure Five **1971**

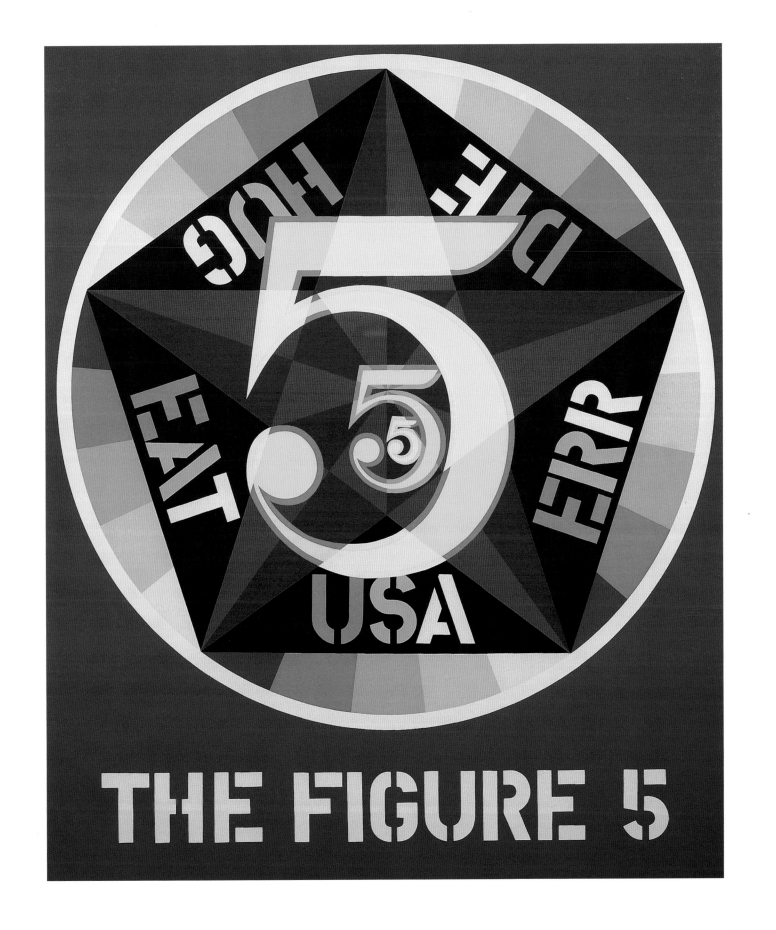

Lee Godie was a fierce, enigmatic bag lady and a permanent fixture on the streets of Chicago for almost thirty years. A self-proclaimed French Impressionist swathed in extravagant piles of rags and stage makeup often concocted from her paintbox, she perched outside the Art Institute on South Michigan Avenue selling her paintings to passers-by, pilgrim-like collectors and generation after generation of art students. Despite her ragged appearance and far from demure behavior, Godie channelled the carefree exoticism and glittering beauty of the Roaring Twenties in her art. Working with a variety of media on cut scraps of canvas (often window shades), she developed a vocabulary of extreme femininity, of wide eyed contessas with bright red lips and flowing locks, of continental madames with secrets to keep, and of the rarefied world they inhabited. "Untitled (Yellow Birds and Daisies)" is an unusually large example of Godie's work from her final, "Neiman Marcus," period, made while she ensconced herself outside the department store on Michigan Avenue in the mid '80s. In 1992, with her health rapidly deteriorating, Godie was officially recognized and rewarded with a career retrospective at the Chicago Cultural Center. She died four months later, having spent most of her adult life promoting and fending for herself on the streets, and remains a Chicago legend.

Untitled (Birds and Flowers) c. 1985

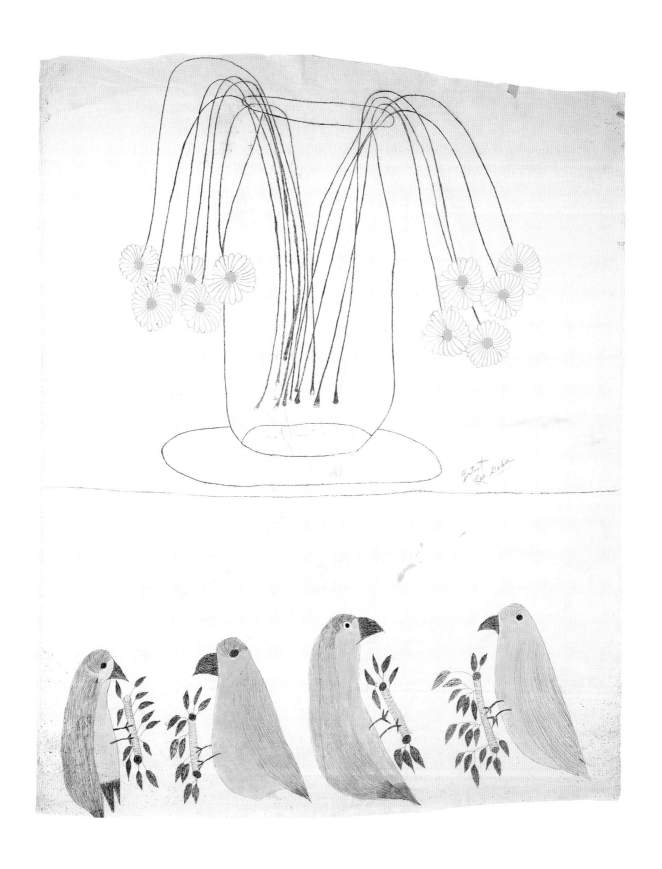

From Donald Baechler's point of view, the awed reverence and untouchable #1 status of American art in the 1960s became something akin to cultural chauvinism, provoking a nonsensical perceived triumph: that this nation was now responsible for the best and most beautiful art in the world. Even though he showed at the happening Tony Shafrazi Gallery in the early '80s, these gentle, democratic beliefs set him apart from comparable East Village artists of the period, second generation Popsters like Kenny Scharf and Keith Haring. Baechler's output includes drawings, paintings, collage and sculpture, and he makes work without discrimination, pomp or chest-beating alliance with an art movement or scene. Working from a massive cache of images and objects that he has collected and catalogued over the years, Baechler transposes the information and manipulates it until he is satisfied. He clones and multiplies, erases and subtracts. The result is rich, dense, fuzzy and friendly mathematics. Baechler continues to exhibit regularly and is very widely collected. His work can be found in New York at the Whitney Museum, Guggenheim Museum and the Public Library, at the Museum of Fine Arts in Boston, MoCA in Los Angeles, the Stedelijk Museum in Amsterdam, and the Centre Georges Pompidou in Paris.

Untitled 1995

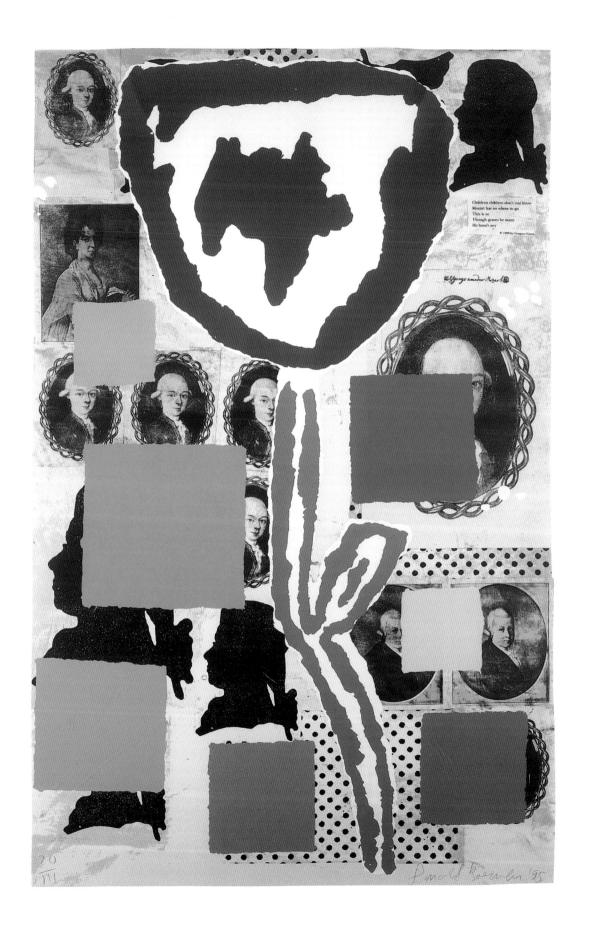

Camp, or Moved, Wagons, Why Not Get One? c. 1963

Born in 1898 in Germania, Texas into a German-speaking Lutheran family, Eddie Arning spent the majority of his adult life in institutions and nursing homes. He lived and worked on his family's farm until 1928, when a series of violent outbursts, culminating in an attack on his mother, led to a year of treatment at Austin State Hospital. He was released briefly only to be committed in 1934 after a relapse of symptoms diagnosed as schizophrenia. However, Arning only began his artistic activities three decades later, in 1964, at age sixty-six. Helen Mayfield, a hospital employee who practiced an early form of art therapy, encouraged her patient to draw, and though initially hesitant, Arning went on to produce over 2,000 drawings in about nine years. His early work was in crayon, depicting largely still lifes, animals, and landscapes inspired by memories of farm life. By 1966, he had incorporated human figures, and in 1969, he switched medium to craypas, which allowed for denser and more varied color choices and textures. A fanatical collector of sundry items that caught his eye, Arning eventually began to work exclusively from clipped magazine advertisements, translating these banal but strikingly composed images of commerce into heavily stylized and highly personal arrangements of simplified, abstract shapes and bold planes of color. Arning's distinctive iconography encompasses both geometric abstraction and narrative work. "Covered Wagon" exemplifies his early style, a definitively limned twisting of perspective that flattens the subject to satisfy the artist's hungry eye. Employing both crayon and craypas, Arning interprets the internal logic of the wagon, distilling its entirety to essential shapes and formal relationships that he wished to emphasize. The drawn frame edging the paper is characteristic of his desire to cover a whole surface and present a completed work – what he called "a nice picture" – that transcended the source material. Arning stopped working in 1973, when he was asked to leave the hospital for unspecified bad conduct. The sale of his work had paid for his hospitalization and achieved for him a certain degree of fame, but despite subsequent stays in various nursing homes, he never picked up crayons again in the last twenty years of his life. His work can be found in the collections of the Philadelphia Museum of Art, the Milwaukee Art Museum, the National Museum of American Art and the Museum of American Folk Art.

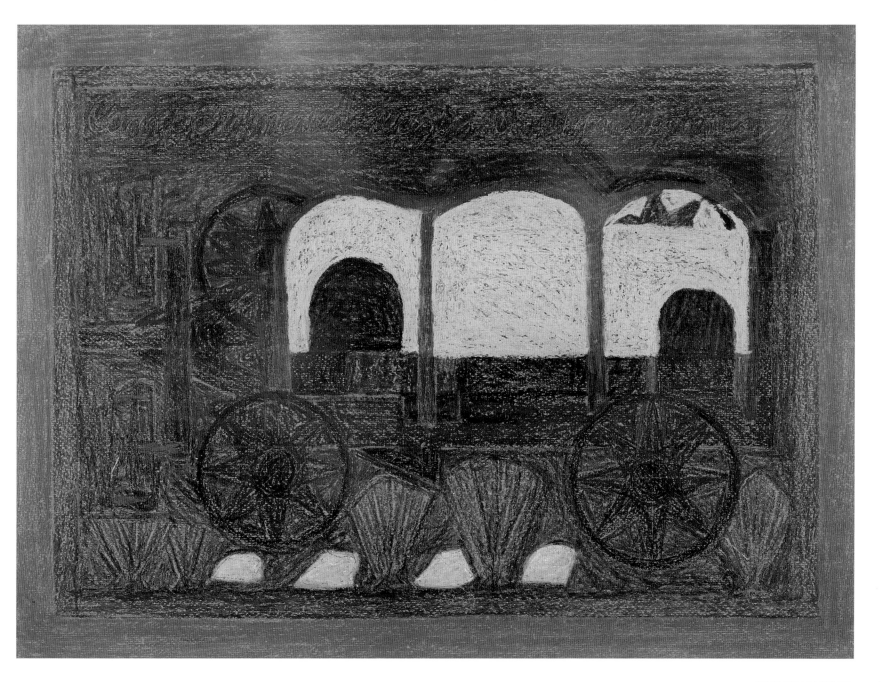

After graduating from high school Tony Fitzpatrick became a Golden Gloves prizefighter in his native Chicago. Self-taught and self-made, his artistic career began in the early 1980s with poetry slams and small slate drawings illustrating his verse. His large body of work draws on tattoo flash, jailhouse lore, hobo drawings and modern mythology. "Azul" and "Rubio" are classic Fitzpatrick prints: intricately ornate and rhythmic (despite their miniature scale); exposing a tender heart as well as a gambler's roustabout ways. In addition to his prolific art practice, Fitzpatrick is an acclaimed actor, radio personality and sometime philosopher, and his work can be found in many distinguished public and private collections including the Museum of Modern Art, New York, The Museums of Contemporary Art in Chicago and Miami, the National Museum of American Art in Washington, D.C., the Art Institute of Chicago and the Philadelphia Museum of Art.

Azul 1997

Rubio 1997

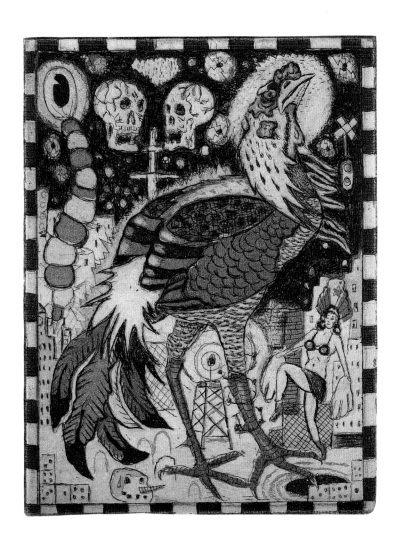
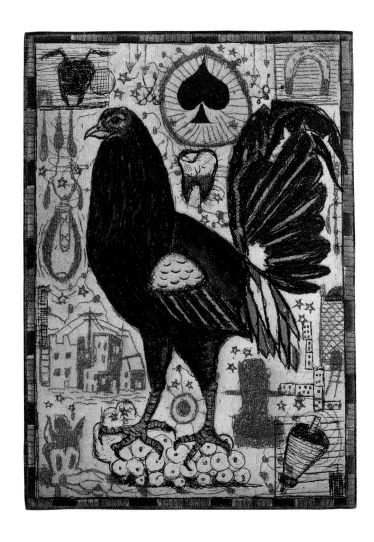

Disillusioned with the consumerism and waste he saw in America after the Second World War, Jon Serl abandoned his career as a distinguished Hollywood voice-over actor and devoted his life to painting. Born into a family of travelling vaudeville performers, Serl's vivid song-and-dance spirit pervades his lyrical and often carnivalesque compositions. "Family Band" depicts a group of disparate individuals, wild and colorful, working together to make a joyful noise. The way their limbs link together may not be seamless or elegant, but they are a family, as weird and idiosyncratic as any family, and in Serl's eyes the cacophony created by their collective effort is cause for celebration. Serl lived to 100 and created a massive body of work, significant pieces of which are in the permanent collections of the American Folk Art Museum, New York, the New Orleans Museum of Art, The National Museum of American Art in Washington D.C., the Milwaukee Art Museum and the Laguna Beach Museum of Art, California.

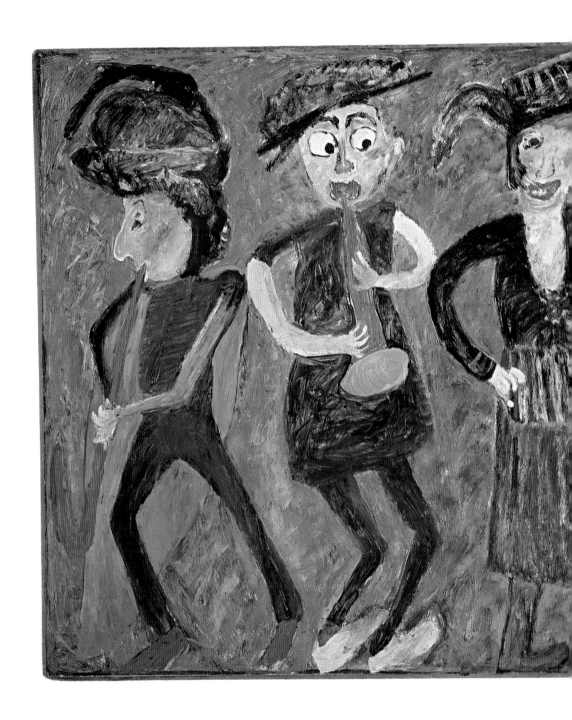

Family Band c. 1970

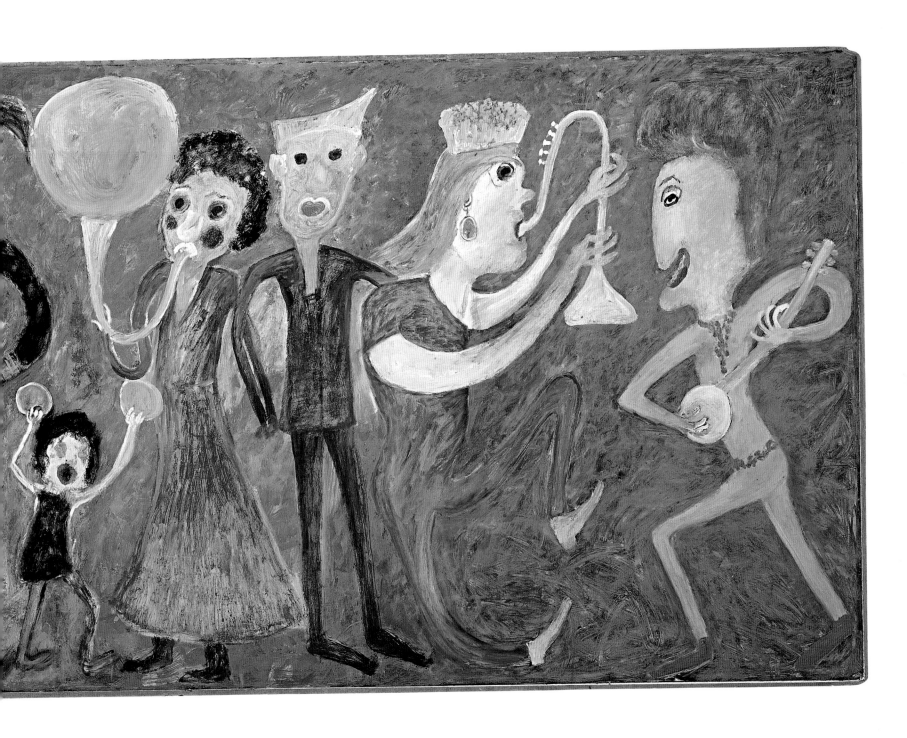

Using his hands and fingers to divine in paint a multifarious iconography, Cuban artist José Bedia taps into the keen prophetic visions of the religions and cultures he studies so assiduously. Initiated as a priest into the Afro-Cuban Palo Monte religion in 1982, shortly after graduating from Havana's Superior Institute of Art and School of Art of San Alejandro, Bedia deems the visual and shamanistic influences of indigenous societies like the central African Kongo culture and the Lakota (Sioux) Nation of South Dakota to be as vital in catalyzing his work as the Modernist rituals of artists like his mentor, the Cubist Wilfredo Lam. Working in ink, acrylic, and charcoal on paper and canvas – and occasionally through sculptural installations – Bedia illuminates the common threads inherent to the spirituality of art practice, creating dense and intense pictures at once obscure in subtext and strangely familiar in their analysis of traditional imagery. His energetic work is populated by silhouetted grotesques, animal totems and chimeras, each linked to a specific mythic figure, often elucidated by Palo or Lakota songs and prayers inscribed on the canvas. Recalling Western self-taught art, academic Neo-Expressionism, and ethnographic art alike, Bedia's singular work flirts unabashedly with concepts of revelation, transcendence, and expiation. José Bedia first received international recognition in 1987 when he represented Cuba in the XIX Bienal Internacional de São Paulo. Currently a resident of Miami, his work has been exhibited internationally and belongs to the collections of The Philadelphia Museum of Art, the Whitney Museum of American Art, and Harvard University's Fogg Art Museum.

Almas del Naufragio II 1997

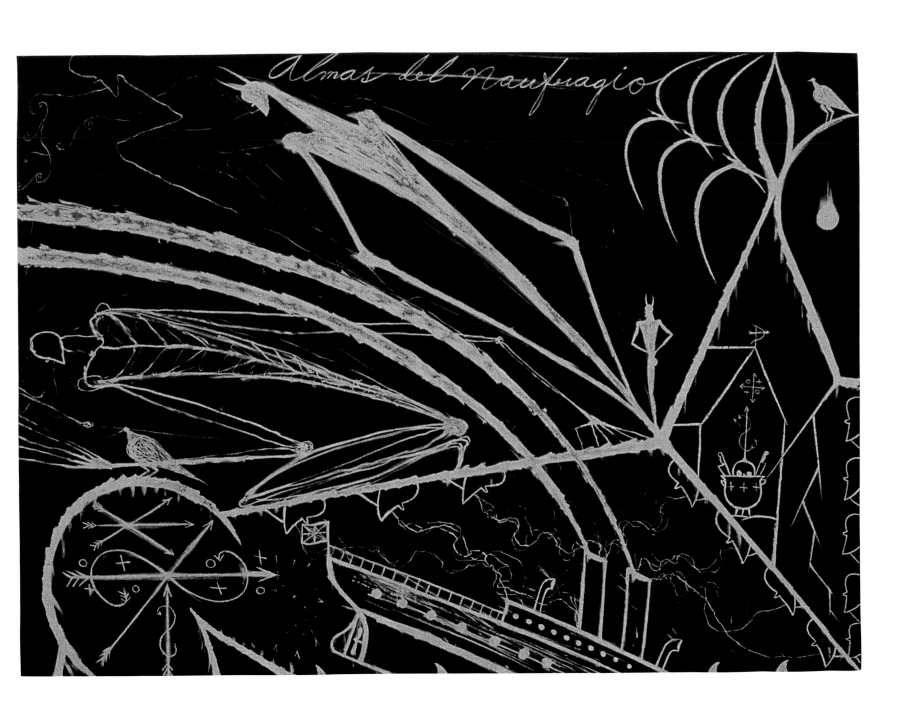

The Tim Rollins + Kids of Survival
(KOS) collaborative deconstructs and
filters literary classics through the street
savvy, trash-talking parlance of urban
special-ed students. The KOS collective,
founded in the early 1980s out of School
52 in South Bronx, NY, introduced
learning disabled students to such classic
texts as Kafka's *Amerika*, as well as *The
Autobiography of Malcolm X* and
Hawthorne's *The Scarlet Letter*. "Amerika"
is arguably the most lauded of KOS'
earlier works; dissected and mounted on
canvas, each page is overlaid with
interpretive drawings representative of
the "cryptic histrionics" of the source. In
this case, text is overlaid with interwoven
golden horns symbolic of the cacophonic
finale. Rollins' New York School of Visual
Arts education was steeped in
conceptualism, influenced by Joseph
Kosuth and Hanne Darboven. Ever loyal
to the SVA royalty, Rollins' highly
conceptual works propose social
betterment through artistic practice. He is
represented by Mary Boone Gallery in
New York and his work is in the
permanent collection of the Hirshhorn
Museum and Sculpture Garden in
Washington, D.C.

Amerika 1988

wise the loss of it would not have been so serious, for the suit which he was wearing was actually better than the one in the box, which in reality was merely an emergency suit that his mother had hastily mended just before he left. Then he remembered that in the box there was a piece of Veronese salami which his mother had packed as an extra tid-bit, only he had not been able to eat more than a scrap of it, for during the voyage he had been quite without any appetite, and the soup which was doled out in the steerage had been more than sufficient for him. But now he would have liked to have the salami at hand, to present it to the stoker. For such people were easily won over by the gift of some trifle or other; Karl had learned that from his father, who deposited cigars in the pockets of the subordinate officials with whom he did business, and so won them over. Yet all that Karl now possessed in the way of gifts was his money, and that he did not want to touch that for the time being, in case he should lose his box. Again his thoughts returned to the box, and he simply could not understand why he should have watched over it on the voyage so vigilantly that he had almost lost sleep over it, only to let that same box be filched from him so easily now. He remembered the five nights during which he kept a suspicious eye on a little Slovak, whose bunk was two away from him on the left, and who had designs, as he knew, on the box. This Slovak was merely waiting for Karl to be overcome by sleep and doze off for a minute, so that he could manoeuvre the box away with a long stick which he was always playing or practising with during the day. By day the Slovak looked innocent enough, but hardly did the night come on than he kept rising up from his bunk to cast mournful glances at Karl's box. Karl had seen this quite clearly, for every now and then someone would light a little lamp, al-

9

Faustroll/Air **1989**

Despite studying in Philadelphia and New York in the 1930s and '40s, amid the fever dream of American Surrealist activity and the roiling roots of Abstract Expressionism, the enigmatic Thomas Chimes has built a constantly evolving body of work that deliberately runs contrary to contemporaneous fashions in the art world. His multifaceted and mercurial work has progressively unfurled formally and conceptually from philosophical investigations of interiority and personal memory through heartfelt tributes to historical thinkers and finally, to an intrepid mapping of an obscure, symbolic metaphysics. Chimes' 1960s sculptural wall work echoes Surrealism's solipsistic sounding of individual consciousness, anchored by his fetishistic, metal-armored box constructions, which feature robo-erotic elements harking back to Dada. In the 1970s, he painted nostalgic, sepia-toned portraits of famous modernists ranging from Charles Baudelaire to James Joyce to his intellectual mentor, Theater of the Absurd prophet and self-described "Pataphysician" Alfred Jarry (1873-1907), author of the infamous *Ubu Roi*. Chimes based these intimately scaled, realistic paintings on photographs and couched them in wide wooden frames. By the '80s, he had limited his palette to titanium white and Mars black, producing hazy, atmospheric portraits (often of Jarry's literary alter ego Dr. Faustroll) and landscapes (often of Philadelphia) veiled in copious glazes that lend the pictures a rarefied ethereality indicative of the artist's interest in "emerging consciousness." Duane Morris' striking painting dates to this "white" period, depicting an imagined Dr. Faustroll on a metaphorical bicycle odyssey through Philadelphia's Fairmount Park, as if blurrily captured by an antique camera. In the last decade, the always restless Chimes turned to an exploration of an expansive and mystical cosmology. Employing arcane, rune-like symbology and pseudo-scientific (or "Pataphysical") diagrams and texts, he produced weird white and gray sign-paintings devoted to repeated cartographic motifs and stylized Jarry character studies.

Twelve miles northwest of Vienna, Austria, in the scenic Wienerwald (Vienna Woods), stands a unique, colorfully emblazoned institution known today simply as "The House of Artists," but commonly referred to by its location, Gugging. In the late 1950s, Dr. Leo Navratil of the Maria Gugging Psychiatric Clinic began encouraging his patients, many of whom suffered from schizophrenia and autism, to engage in artistic activities. Over the course of the next two decades, Navratil discovered that many of his patients possessed extraordinary – but previously untapped – creative talents. His research led to exhibitions and publications of these artists' work, which in turn resulted in international interest in Austrian Art Brut. In 1981, Navratil was permitted to move his most artistically inclined patients into a separate facility, where a community environment that supports full-time artmaking nurtures this unusual artists' collective. Born deaf and mute in 1920 in Hainburg, Lower Austria, Franz Kamlander was an exception among most of his Gugging peers, as he demonstrated a propensity for art before he entered the institution at age 37. Unable to read or sign traditionally, Kamlander developed his own personal sign language and visual iconography in order to communicate with the world. Possibly drawing from his experience as a farm worker early in life, he drew and painted almost exclusively animals, and particularly cows, working feverishly to record his impressions of solitary beasts and always signing his work with three undulating lines. Despite their light, sketchy quality and undeniable urgency, his works read as expressionistic portraits of individual, albeit imagined, animals, and his use of color is deliberate and sensitive, though rarely naturalistic. Kamlander died in 1999 in Melk, Lower Austria.

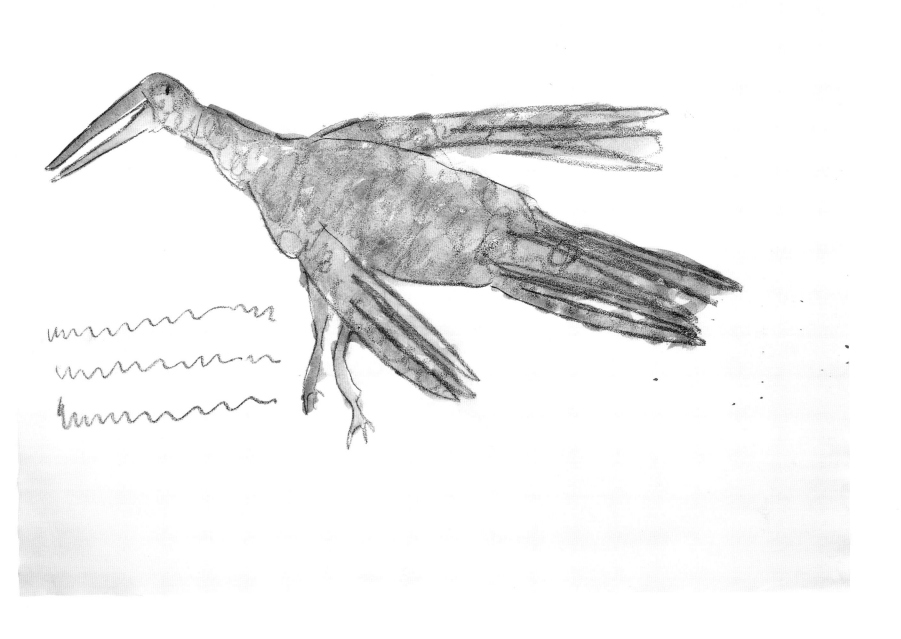

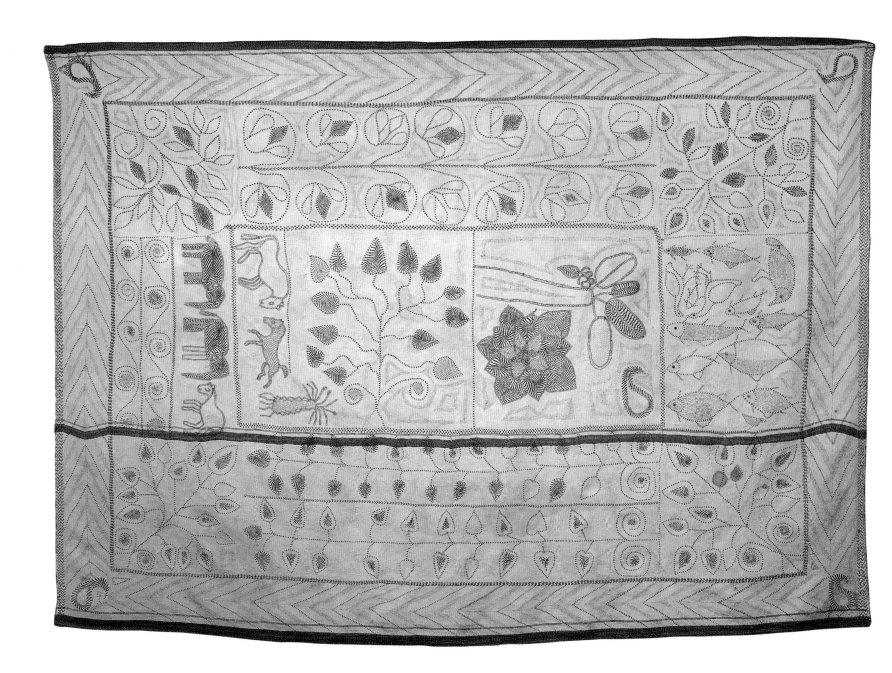

Unrecognized by the outside world until the 1920s, Bangladesh's extraordinary *nakshi kantha* textiles developed as an exceptionally mobile set of skills, patterns and models among the women of East Bengal, who traded techniques and designs freely between communities and generations. This generous exchange is appropriate for a craft tradition based conceptually on a fusion of Hindu, Sufi and Buddhist visual vocabularies and concretely on a recycling impulse. *Kanthas* are multilayered wraps or spreads made from salvaged textiles – *sarees, dhotis* and *lungis* – stitched together with minute, ornamental needlework to reinforce and thicken the worn-out component cloths for further use. Demonstrating a remarkable formal range, these fabrics, seldom commissioned and generally intended for everyday domestic rather than ceremonial functions, serve foremost as visual diaries for Bengali women. However, they likewise fulfill a variety of practical roles: as attire, spreads, quilts, wallets, clothes and cosmetics wrappers, ceremonial meal cloths, wedding gifts, prayer mats, and pillow covers. A unique fusion of whimsy and spiritual iconography, rich geometric abstraction and pictorial representation and narrative, *kantha* needlework depends both on climate (which dictates the requisite gauge and density of the garment) and regional cultural expression and stylistic innovation. Duane Morris' *kantha* (one of many in their collection) exhibits the delicate line quality, simple borders, and vegetal, floral, and animal patterns typical of the Khulna and Kushtia districts of Bangladesh.

Rising to prominence with the 1966 Hairy Who exhibition, Karl Wirsum remains a central figure of the Chicago Imagists, a group of artists who graduated from the Art Institute of Chicago in the late '60s. His work, paintings and cut-out relief sculptures alike share a frenzied, intricately patterned design sense and a blisteringly loud palette. Of all the Imagists, Wirsum's work is arguably the most consistently humorous, employing wild visual and verbal puns and a heavily cartoon-influenced graphic. The fantasy world Wirsum populates with his grotesques and goons is akin to that of fellow Imagist Jim Nutt, and his technique is similarly polished, but Wirsum's work is flatter, less illusionist, and altogether more electric and psychedelic. "Double Duck Talk" exemplifies Wirsum's later work, a refinement of his rowdy early style, but still simultaneously referencing American popular culture and the rhythmic complexity of African art. Wirsum was included in the official U.S. entry to the 1973 São Paolo Bienal, and today his work resides in the Whitney Museum, The Art Institute of Chicago, and the National Museum of American Art.

Double Duck Talk **1989**

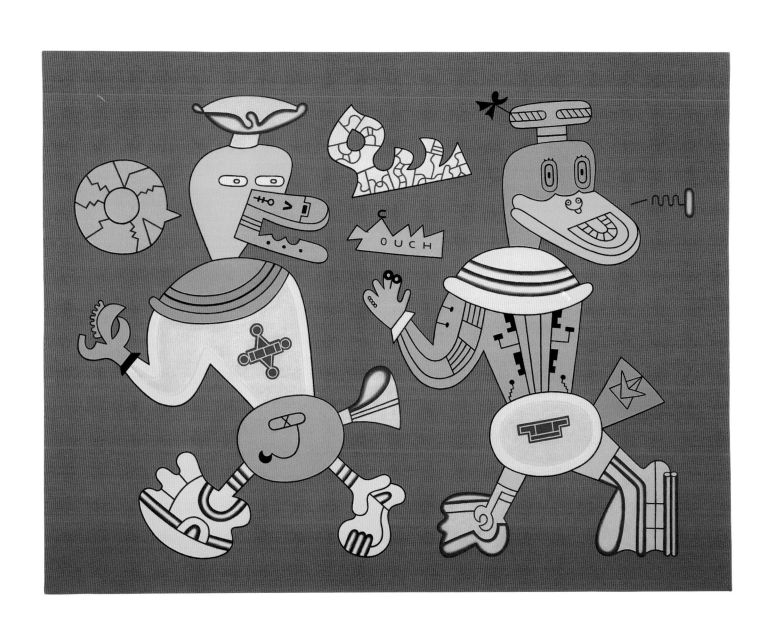

After preaching for forty years, The Reverend Howard Finster was called upon by God to transform his repair shop in Summerville, Georgia into *Paradise Garden*, a giant assembled village of rescued trash items embedded in concrete around a 30-foot tall tower of bicycle parts. For this environment and the Garden's centerpiece, the functioning "World's Folk Art Church, Inc.," Finster achieved local celebrity status. Following another vision in 1976, when Finster saw a man's face appear and speak to him from a paint smudge on his finger, he took up painting and began to build his formidable body of "sermon art." With a voracious and intuitive approach to art-making, Finster tirelessly painted his messages from God in dense, vivid arrangements of text and image. Finster's work was first exhibited in a museum setting in 1977, and it caused an instant sensation in the art world thanks to his deep moral messages conveyed in a warm, emotionally universal tone. In 1980 he was exposed on a national stage through a feature in *Life* Magazine, and in the years following hit *The New York Times*, *Chicago Sun-Times*, *Life* and the cover of *The Wall Street Journal.* Finster has been exhibited extensively, from The Smithsonian Institute to the Library of Congress, and is held in the nation's foremost collections, including the High Museum in Atlanta, the National Museum of American Art in Washington, D.C., the Philadelphia Museum of Art and the Milwaukee Museum of Art. Additionally, Finster became so revered in the art community that he was commissioned to design album covers for the rock bands Talking Heads and REM. "If You Meet Me" is a fine example of the Reverend's experimental early output. Two layers of glass embedded in a wooden box give the effect of a three-dimensional scene, with figures ascending to heaven as repayment for their piety and love, while a typically heartfelt, humorous message borders the scene, the back and the inside. Finster cannot hold himself back, and his vision of hope spills ever over the edges.

If You Meet Me 1982

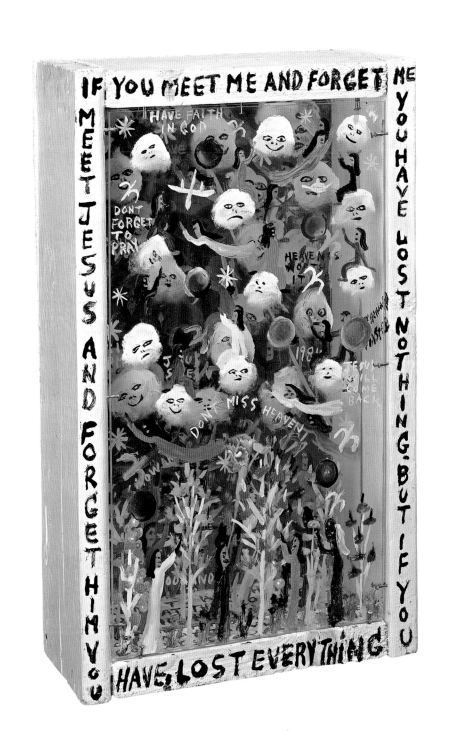

On the streets of Overtown, a shabby slum outside the sparkling Miami downtown, Purvis Young has painted and drawn inspiration for his entire life. A tearaway youth in a beatnik beret, Young flirted with petty crime and pool hustling in his teens, a lifestyle that led him to a three-year spell in Raiford State Prison. Upon his release in 1964, Young found inspiration in books depicting new inner-city murals "up north," so-called "Freedom Walls" in Chicago and Detroit, and decided that he must uplift and beautify his own neighborhood through art. His first major public act appeared in the late '60s on Good Bread Alley, a formerly beautiful Overtown area spoiled by the rough construction of interstate I-395 through its center. Young tacked up hundreds of housepaint on plywood paintings along a row of boarded-up houses, creating galloping horses, dancing men and women, jazz musicians: a litany of brave and unrestrained characters raging against the decay of their immediate surroundings. Duane Morris' is such a work, showing a grey mass of humanity mobilized and elevated by a higher force. Painting in a variety of media on whatever he could lay his hands on, be it discarded wood and sheet metal, accumulated bundles of paper and carpet scraps, the artist turned his society's refuse into art that would enrich it. Young has experienced great success and recognition since his first murals, and still makes his ecstatic, pulsating paintings in Miami. His work can be found in the permanent collections of the Studio Museum of Harlem, the New Orleans Museum of Art, The Newark Museum and the Art Collection of the University of Miami.

Untitled c. 1980/90

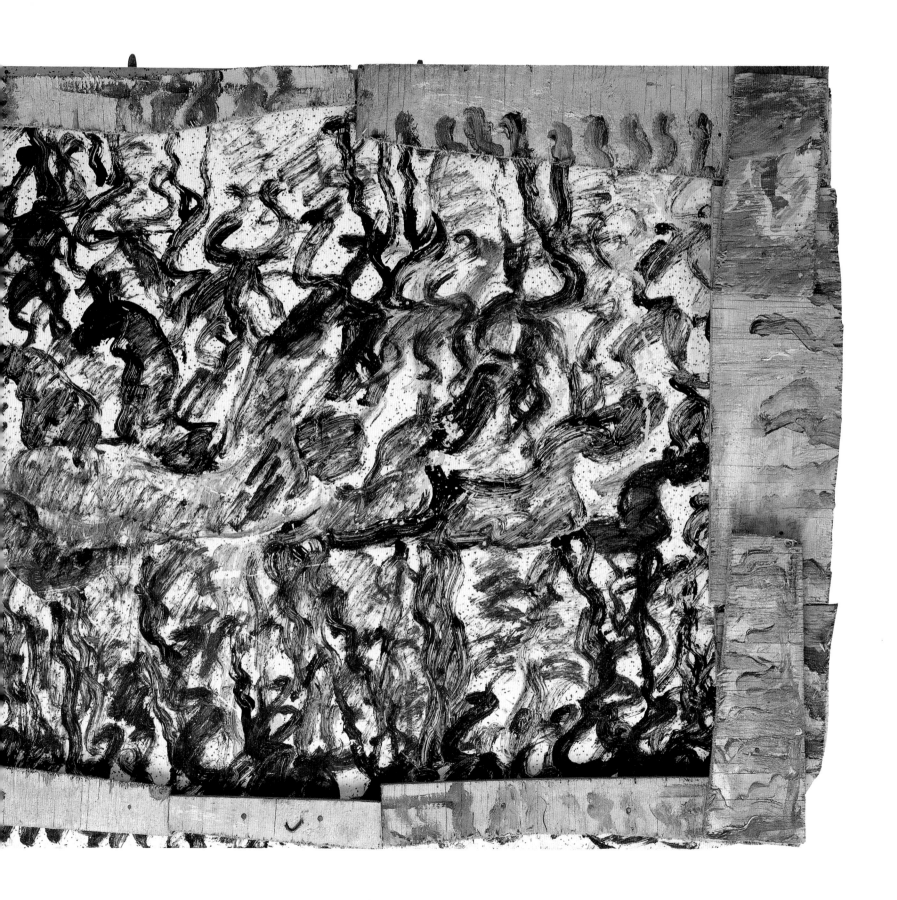

Born in 1933 in Tupelo, Mississippi, Sam Gilliam ranks among the most historically significant African-American artists of the 20th century. Upon graduation from Louisville University in 1961, Gilliam moved to Washington, D.C., quickly acclimating himself to that city's dynamic, reactionary art scene. Colorfield painters like Mark Rothko, Helen Frankenthaler, and Barnett Newman were quickly becoming major world forces in the '60s. D.C.-native colorfielders Kenneth Noland and Morris Louis, known for their immense, boldly expressionistic, color-saturated works, were greatly influential in Gilliam's early career. During this time, he was also socially involved with local jazz gods Thelonius Monk and Ramsey Lewis, who helped develop the uniquely soulful draped-canvas oeuvre for which he is most famous. Gilliam's fluid post-colorfield painting takes on three-dimensional space, effectively breaking with its modernist ties. By adapting his revered jazz contemporaries' jagged, subversive edge, Gilliam reached this seminal point in his career. His stretcherless paintings from the mid-sixties draped museum exteriors, shaded windowless gallery walls and disguised sawhorses. Works from this period are included in such prestigious permanent collections as the MoMA and Corcoran Museums. Gilliam's later works are a continuation of this format, but with direct reference to Russian Constructivist style; the irregularly shaped canvases take on enormous proportions evolving excised geometric forms and architectural elements that recall Frank Stella and Elizabeth Murray.

Untitled 2001

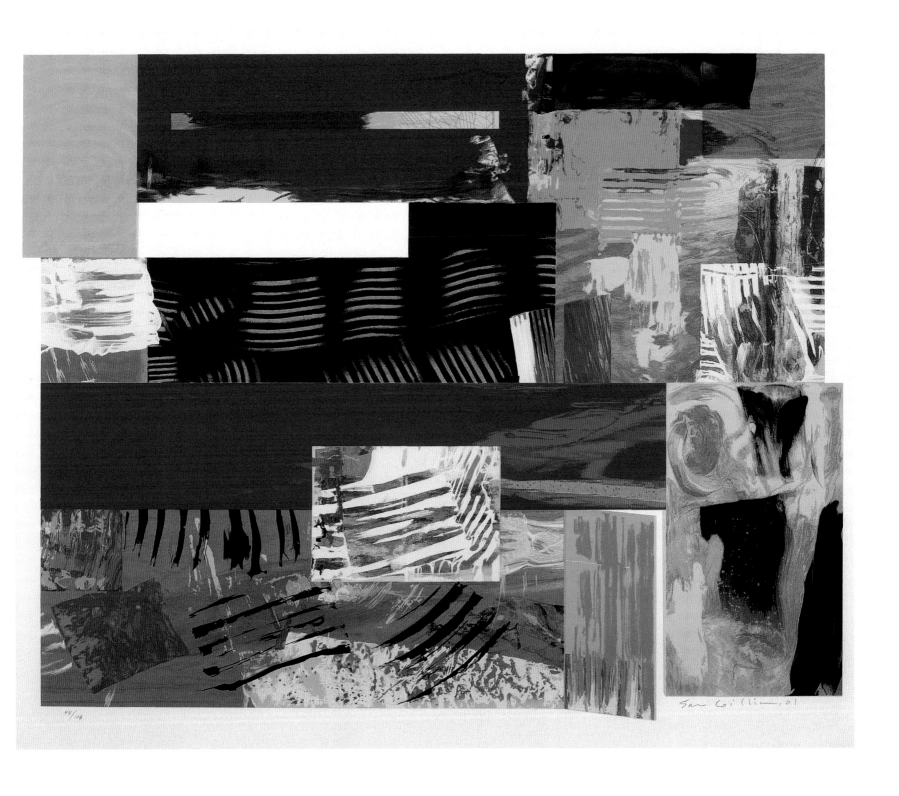

44/108

Augur **1991**

A 1981 graduate from Moore College of Art and Design in Philadelphia, the only all-woman art school in the nation, Norinne Betjeman emigrated to England in the early '90s, where she lives today. Betjeman is expert at pushing the techniques of photographic processing, taking the act to a level that is closer to fine art printing and miles from the mechanical. Working on enormous, hand-cut pieces of photo paper, Betjeman multiply exposes her compositions to include giddy shifts in scale and provocative, surrealistic switches in subject matter within a single frame, and hand tints and colors the images to blur the boundaries between real and imagined histories. Carefully photographed landscapes juxtaposed with archaeological artifacts encourage the viewer to look, with wonder, into the complexity of our environment, and see the strength in it lest it all turn to ruins. Betjeman is in many public collections in Philadelphia, including Moore College, the Convention Center, the Orchestra, the Museum of Art, the State Museum and Bryn Mawr College, as well as the Boca Raton Museum of Art, the Delaware Art Museum, the Bibliothèque Nationale de France, and the corporate collections of Lexus, ARCO and Hewlett Packard.

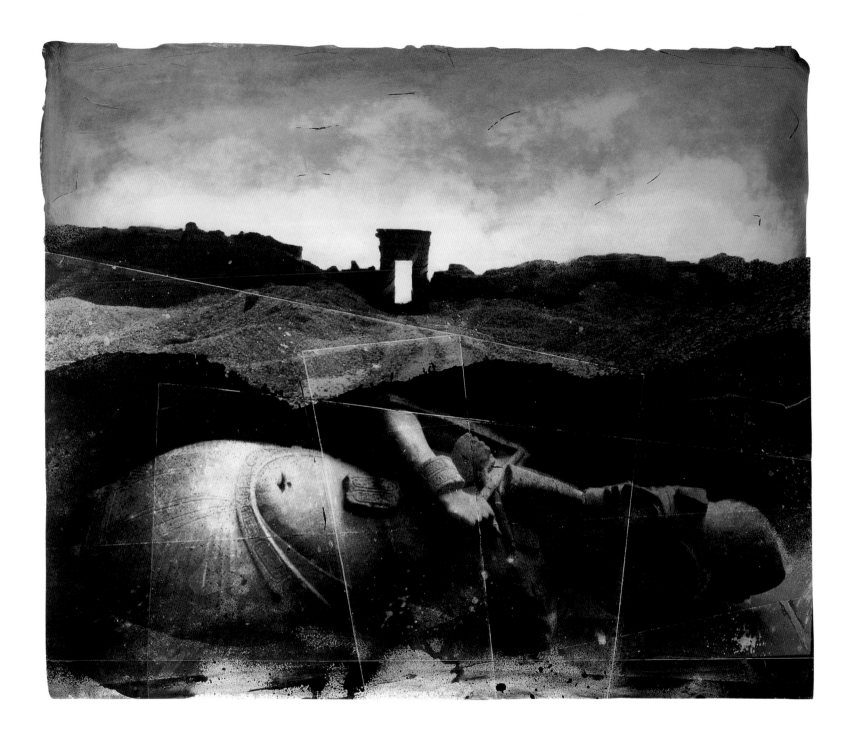

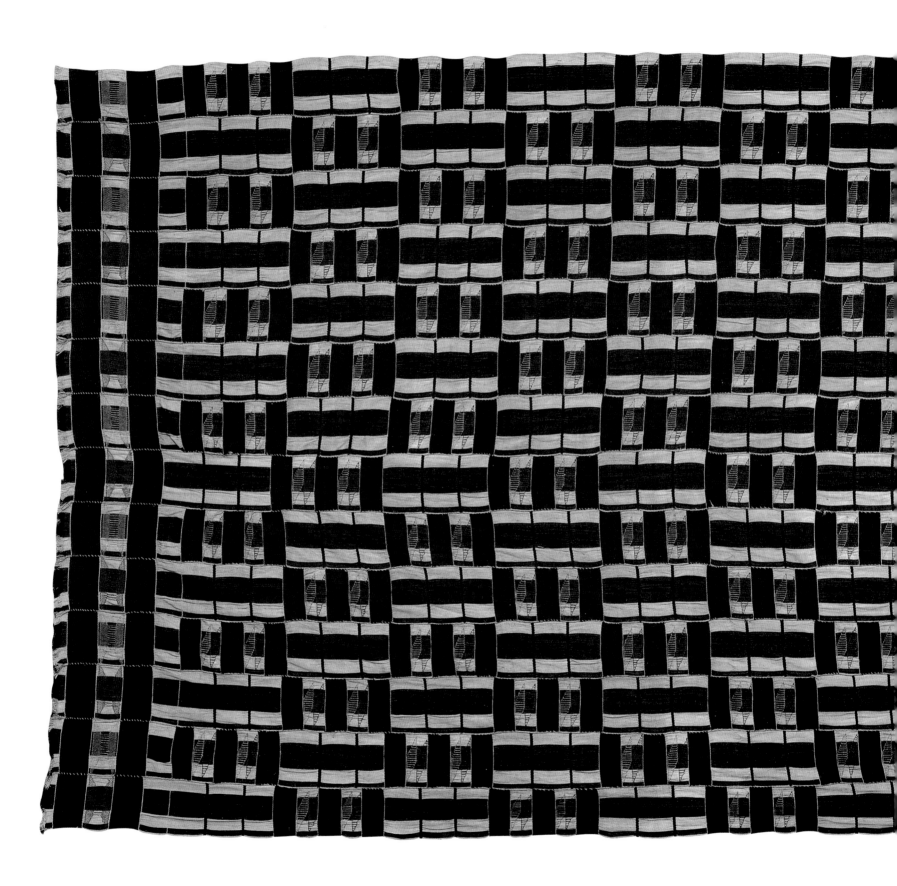

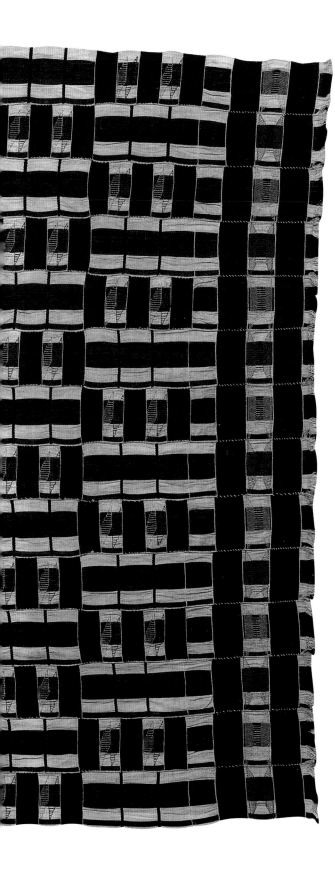

The study of African art has exposed a complex set of symbolic relationships between object, artist, and owner, determined through ritual and practical functions. African textiles often serve ceremonial purposes, many of which strictly prescribe specific patterns (often with particular, poetic names) for different uses and wearers. West Africa's celebrated *kente* cloths originated in the forests of southern Ghana, on the looms of the Asante (Ashanti) Empire. One evocative myth asserts that, during the reign of Osei Tutu, the first weaver learned his art by studying a spinning spider, or Anansi, a folkloric figure representative of trickery and wisdom. We do know that as early as the beginning of the 18th century, Asante (and the less politically cohesive Ewe) weavers had developed methods for mixing their native cotton with foreign silk reclaimed by meticulously unraveling fabrics traded by Southern Europeans. The Ghanaian technique of using two or even three sets of heddles to produce complex, alternating warp and weft float designs in narrow, patched-together strips is unique to the region. These remarkable *kente* cloths, many of which include both abstract geometric patterns and repeated, stylized representations of iconic symbols appropriate to the fabric's function, are created as attire for a specific person. The amount of silk and the complexity, color and content of the design correspond to the intended wearer's social position and the occasion. *Kente* culture enjoyed a renaissance with the African diaspora in the 1960s, when these textiles were adopted as stylish signifiers of Afrocentric identity. Duane Morris' large *kente* (obviously woven for a fashionable man) dates to the mid-20th century, by which point rayon and other synthetic materials had replaced silk as the thread of choice with which to render weft patterns on cotton warp strips.

Kente **c. mid 20th Century**

The early 1970s marked a pivotal point in the thirty thousand-year-old Aboriginal art tradition. *Dreampainting* (which predates the Lascaux cave paintings by roughly twenty thousand years) was previously an ephemeral, sacred rite only exposed to those involved in native religious ceremonies. In 1971, Geoff Barden, a dynamic, Australian art teacher, encouraged a radical transformation to Western consumerist ideals by asking his young students not to paint "like white-feller." "Don't paint no white-feller images," instead he suggested they interpret the Dreampainting-technique of their elders, using acrylics and canvas. Eventually his workshops grew to include the elder Dreamers, who were eager to work with these new saleable, semipermanent materials. Traditionally, Dreampaintings were applied to skin with various pigments found regionally, painted on bark, or outlined in sand as ceremonial ground designs. Through meditation and chanting, the Aborigines of the Western Austrialian Desert channeled ancestors called *Dreaming,* who they believe created the universe in their travels. The *Dreaming* exist for all things and there is a map, or a dreampainting for each of these. While none are identical, the pointillist patterns and vivid desert colors are common formal motifs, as are the recurrent circular patterns, symbolizing nurturance and safety. Pansy Nakamara Stewart dreams paintings typical of the Papuya Tula camp artists of Central Australia. There have been major exhibitions of these paintings around the world – the most notable being at the Asia Society in New York City.

Bush Carrot Dreaming **1988**

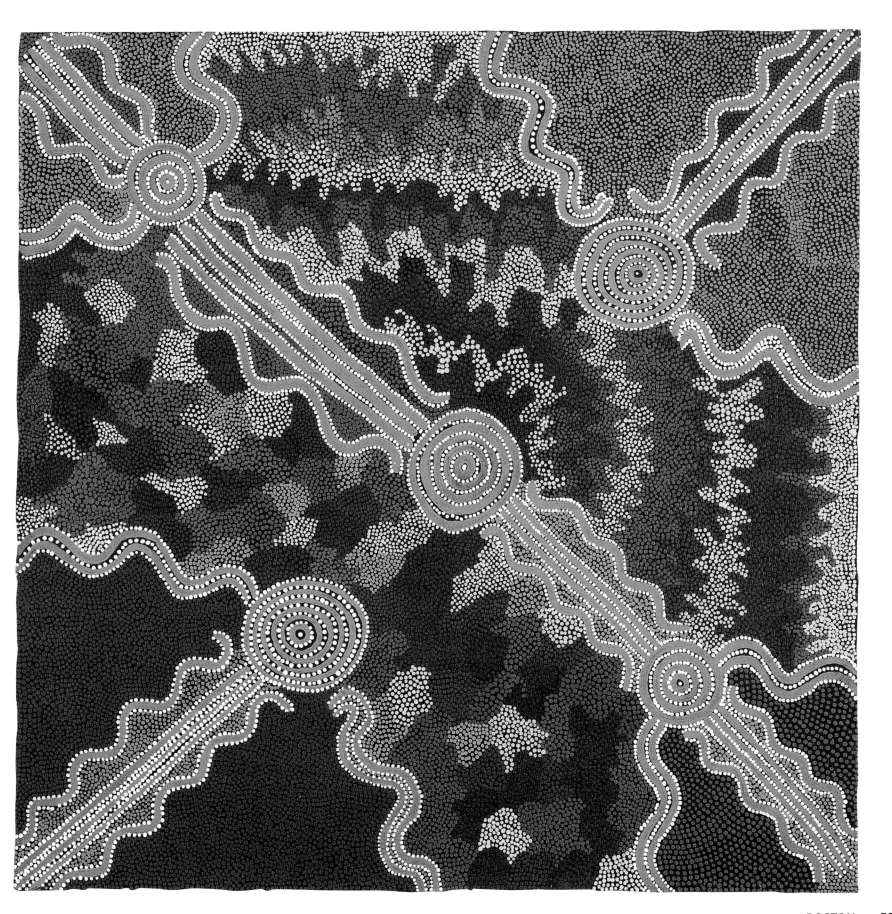

Warren Rohrer was a ninth-generation American. As a Lancaster County Mennonite, he hardly had a wealth of vocational options. He could have been a farmer, he could have been a minister, or he could have been a farmer and a minister. None of these lives particularly appealled to Rohrer, and he enrolled in Eastern Mennonite College and Penn State University with the hopes of becoming a painter. Returning to a barn near his hometown in 1960, Rohrer painted bucolic modern pastorals evoking the peace of a rural upbringing. A more complex, more contemporary practice evolved at the turn of the '70s, when Rohrer began to paint deep abstractions of country life rather than literal reflections of it. The second half of his career incorporated techniques of farming, planting, quilt-making and Mennonite ancestral activities to the technique of painting. Rohrer considered the grids and plots of fields, the patterns and buildup of thread in craftworks, and the plodding persistence of both. Though he flouted familial expectations by becoming a painter, Rohrer ultimately paid reverence to traditional values in studied, respectful abstraction. The Philadelphia Museum of Art looked back over Rohrer's work from 1972-1993 in a comprehensive 2003 retrospective, and Philadelphia's Locks Gallery has given him an astonishing 15 solo shows since 1974. He died in 1995.

Christiana Boogie Woogie **1979**

Duane Morris Offices

New York
London
Chicago
Houston
Philadelphia
San Diego
San Francisco
Detroit
Boston
Washington, D.C.
Atlanta
Miami
Pittsburgh
Newark
Allentown
Wilmington
Harrisburg
Bangor
Princeton
Westchester

http://www.duanemorris.com

Duane Morris LLP - A Delaware limited liability partnership